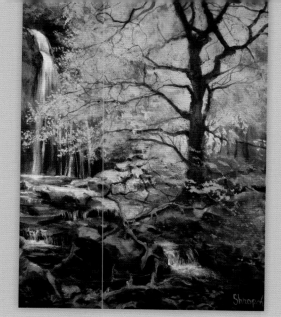

LANDSCAPES

Acrylics are the perfect choice for any artist. They are extremely versatile, and they are the most forgiving when it comes to changes or corrections. Like acrylics, landscapes are also extremely versatile as a subject. From springtime storms to classic winter scenes, each painting in this book was inspired by the beauty of nature.

CONTENTS

TOOLS & MATERIALS

Paints

Paint varies in expense by grade and brand. Very inexpensive paints might lack consistency and affect your results, but buying the most costly color may also limit you. Find a happy medium.

Brushes

Synthetic brushes are best for acrylic painting because their strong filaments can withstand the caustic nature of acrylic. Build a starter set with small, medium, and large flat brushes; a liner (or rigger) brush; a medium fan brush; and a hake brush.

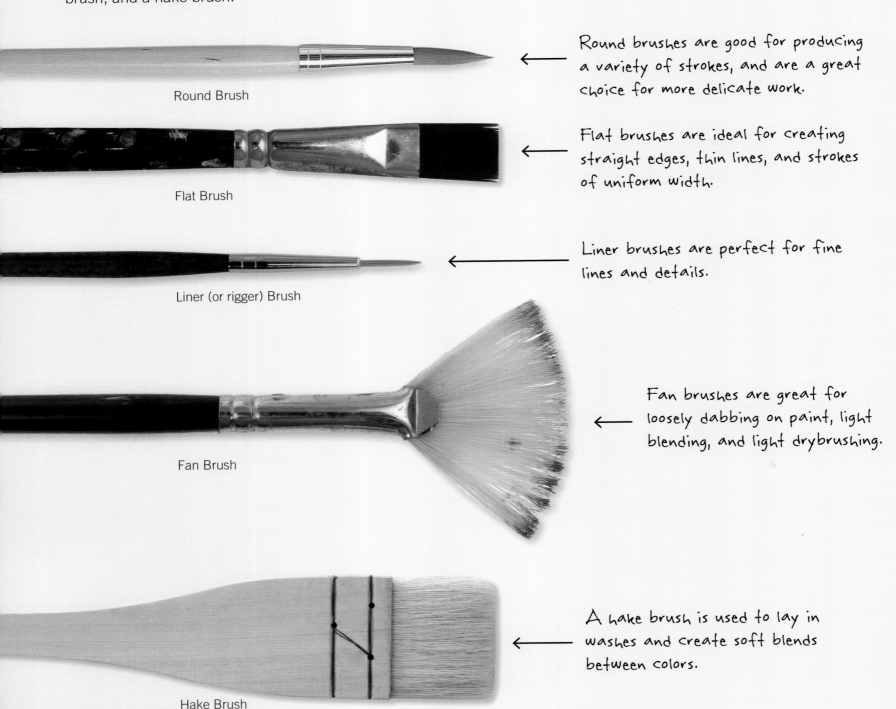

Round Brush

Flat Brush

Liner (or rigger) Brush

Fan Brush

Hake Brush

Round brushes are good for producing a variety of strokes, and are a great choice for more delicate work.

Flat brushes are ideal for creating straight edges, thin lines, and strokes of uniform width.

Liner brushes are perfect for fine lines and details.

Fan brushes are great for loosely dabbing on paint, light blending, and light drybrushing.

A hake brush is used to lay in washes and create soft blends between colors.

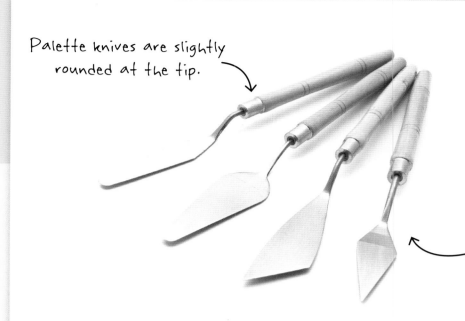

Palette knives are slightly rounded at the tip.

Palette & Painting Knives

Palette knives are mainly used to mix colors on your palette; they come in various sizes and shapes. Some can also be used for applying paint to your canvas, creating texture in your work, or even removing paint.

Painting knives are pointed and a bit thicker, with a slightly more flexible tip.

Palettes

Palettes for acrylic paint range from white, plastic handheld palettes to sheets of plexiglass.

Sponges

Sponges are great for dampening your canvas and applying paint to create texture.

Painting Surfaces

Although you can paint on many surfaces, canvas is the most popular choice. Pre-primed and stretched canvas, which is available at arts and craft stores, is stretched taut over a wood frame and coated with acrylic gesso—a white primer that provides an ideal surface for holding paint.

Additional Supplies

Some additional supplies you'll want to have on hand include:

- ☐ Paper, pencils, and a sharpener for drawing, sketching, and tracing
- ☐ Jars of water, paper towels, and a spray bottle of water
- ☐ Blackboard chalk and/or vine charcoal for sketching over dry paint
- ☐ Acrylic glazing medium or retarder

COLOR BASICS

A basic knowledge of color and color relationships is essential in learning how to paint. One of the easiest ways to approach color is by seeing it on a "color wheel," which is a visual organization of color hues around a circle. Seeing the colors organized in this fashion is helpful for color mixing and choosing color schemes.

Color Wheel

The color wheel helps us see relationships between primary, secondary, and tertiary colors. Primary colors are blue, red, and yellow. We can create a multitude of other colors by combining blue, red, and yellow in various proportions, but we can't create the three primaries by mixing other colors. Secondary colors include orange, green, and violet. You can create these colors by combining two primaries. Red and yellow makes orange, blue and red makes violet, and yellow and blue makes green. Tertiary colors are created by mixing each primary color with its neighboring secondary color. These colors include red-orange, yellow-orange, yellow-green, blue-green, blue-violet, and red-violet.

Complementary Colors

Complements sit opposite each other on the color wheel. For example, red sits opposite green, blue sits opposite orange, and yellow sits opposite purple. These colors are considered opposites in their hues and yield the maximum amount of color contrast possible. When complements are mixed together, they form a dull gray, brown, or neutral color.

Neutral Colors

Neutral colors are browns and grays, both of which contain all three primary colors in varying proportions. Neutral colors are often dulled with white or black. Artists also use the word "neutralize" to describe the act of dulling a color by adding its complement.

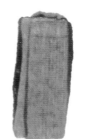

Color Temperature

Color temperature refers to the feeling one gets when viewing a color or set of colors. Generally, yellows, oranges, and reds are considered warm, whereas greens, blues, and purples are considered cool. When used within a work of art, warm colors seem to advance toward the viewer, and cool colors appear to recede into the distance. This dynamic is important to remember when suggesting depth or creating an area of focus.

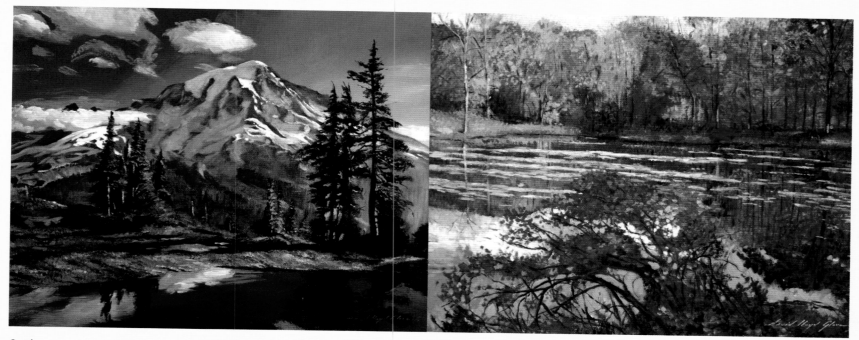

Cool Warm

Color & Value

Within each hue, you can achieve a range of values—from dark shades to light tints. However, each hue has a value relative to others on the color wheel. For example, yellow is the lightest color and violet is the darkest. To see this clearly, photograph or scan a color wheel and use computer-editing software to view it in grayscale. It is also very helpful to create a grayscale chart of all the paints in your palette so you know how their values relate to one another.

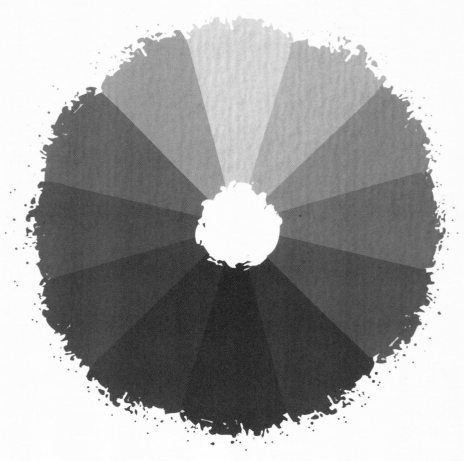

PAINTING TECHNIQUES

Learn to manipulate acrylic paint to create a wide range of strokes, textures, and interesting effects. Here are some of the most common techniques.

Wet-into-Wet Apply color on a dampened canvas or next to another wet color. Blend by lightly stroking over the area where the colors meet. Use your brush to soften the edge, producing a smooth transition.

Stippling Dab on color quickly, creating a series of dots.

Scumbling With a dry brush, lightly scrub semi-opaque color over dry paint, so the underlying colors show through.

Glazing Apply pure, transparent color of watery consistency over an existing color to change, modify, or tone it down.

Wash To create a thin wash of color, thin the paint and stroke it evenly across your surface.

Drybrushing Using a dry brush, apply paint directly to a dry canvas for a rough brushstroke.

Dabbing Use press-and-lift motions to apply irregular dabs of paint. For more depth, apply several layers of dabbing, working from dark to light. This is great for suggesting foliage and flowers.

Painting Knife Applying paint with a painting knife can result in thick, lively strokes that vary in color, value, and height.

Scraping Using the tip of a painting knife or the end of a brush handle, "draw" into the paint to remove it from the canvas.

Spattering Load a brush with thinned paint, and tap it over a finger to fling droplets onto the canvas.

Sponging Apply paint by dabbing with a sponge to create interesting, spontaneous shapes. Layer multiple colors to suggest depth.

Impasto Use a paintbrush or painting knife to apply thick, varied strokes, creating ridges of paint.

Lifting Out Use a moistened brush or tissue to lift color off of a wet wash.

Graduated Blend Stroke two different colors onto the canvas horizontally, leaving a gap between them. Continue to stroke horizontally, moving down with each stroke to pull one color into the next.

TIP

The way you hold your tool, as well as how much paint you load on it, the direction you turn it, and the way you manipulate it will all determine the effect of your stroke.

USING A REFERENCE PHOTO

Reference photos are great tools to help get your painting started. But remember, the goal is to interpret a subject in your own unique way, so don't feel the need to copy every detail.

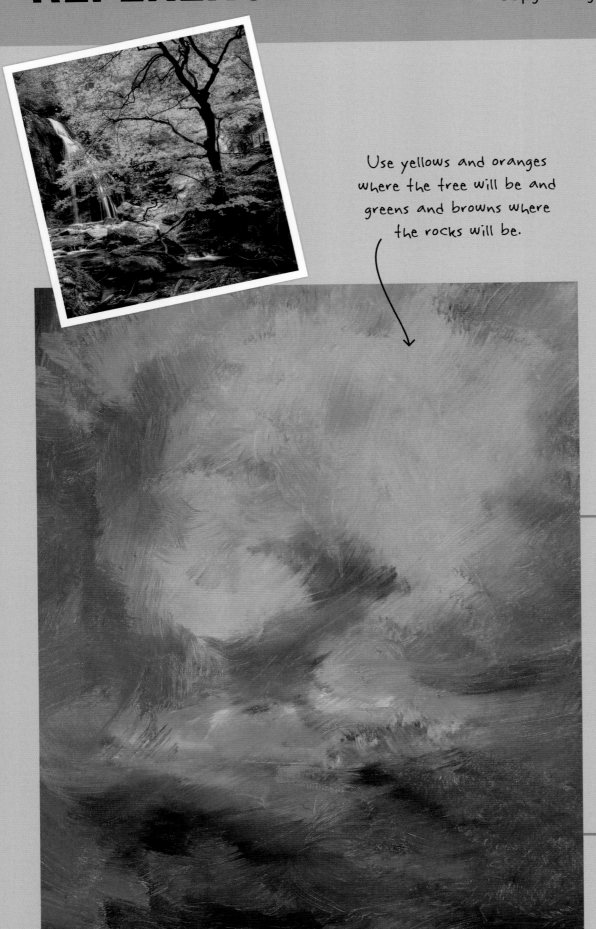

Use yellows and oranges where the tree will be and greens and browns where the rocks will be.

BACKGROUND

- brilliant yellow-green
- burnt umber
- cadmium yellow light
- Hooker's green
- Naples yellow
- red oxide
- titanium white

Detail Establishing the light and dark areas at this stage makes it easier to build details later.

Dampen the canvas with a sponge. Use a large bristle fan brush to block in the background colors, painting wet-into-wet. Keep strokes quick, loose, and varied to create an abstract pattern.

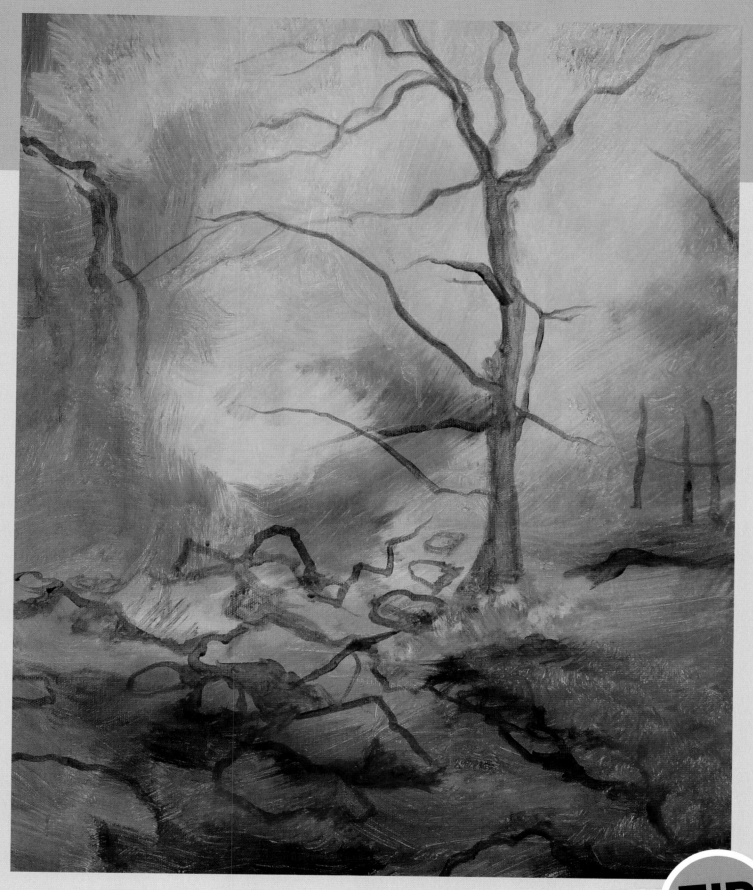

Once the background layer is dry, draw the major elements of the scene using a small round brush and a watery burnt umber mixture. Pay attention to the placement of the waterfall, the tree, and the rocks, but don't worry about details at this stage.

TIP

When drawing outlines, white chalk works well on dark backgrounds, and vine charcoal sticks work well on light backgrounds.

Use a #6 flat bristle brush and titanium white straight from the tube for the waterfall and other light areas.

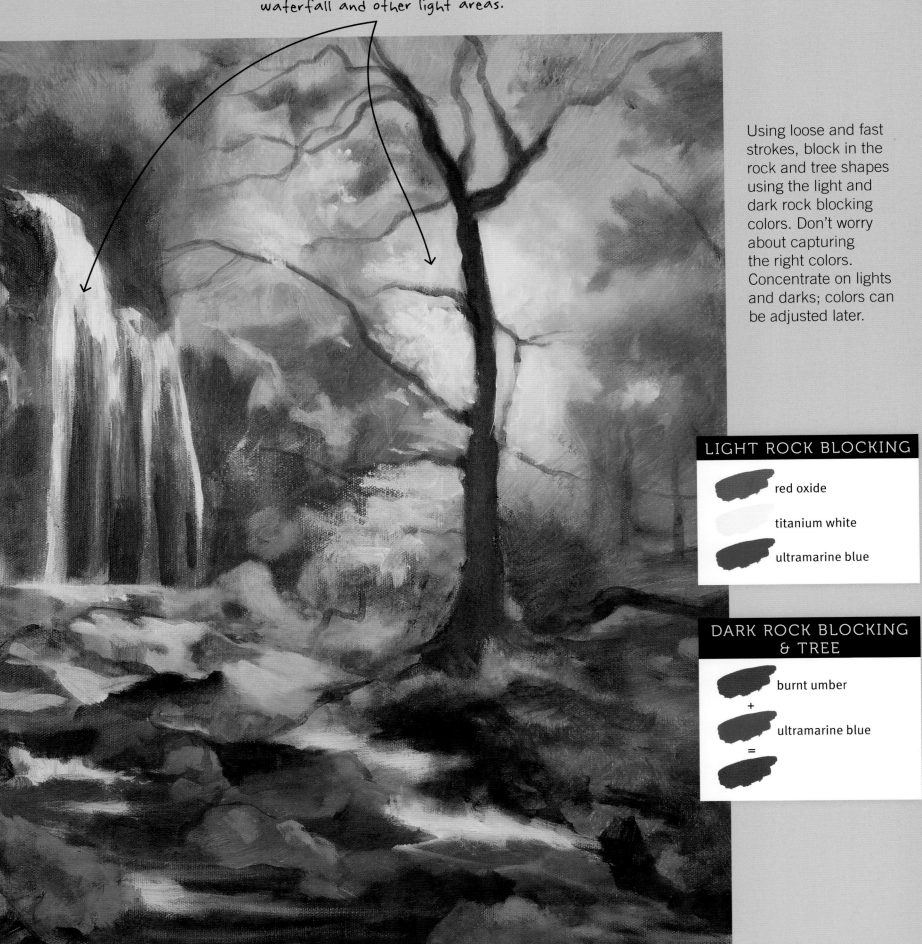

Using loose and fast strokes, block in the rock and tree shapes using the light and dark rock blocking colors. Don't worry about capturing the right colors. Concentrate on lights and darks; colors can be adjusted later.

LIGHT ROCK BLOCKING

red oxide

titanium white

ultramarine blue

DARK ROCK BLOCKING & TREE

burnt umber

+

ultramarine blue

=

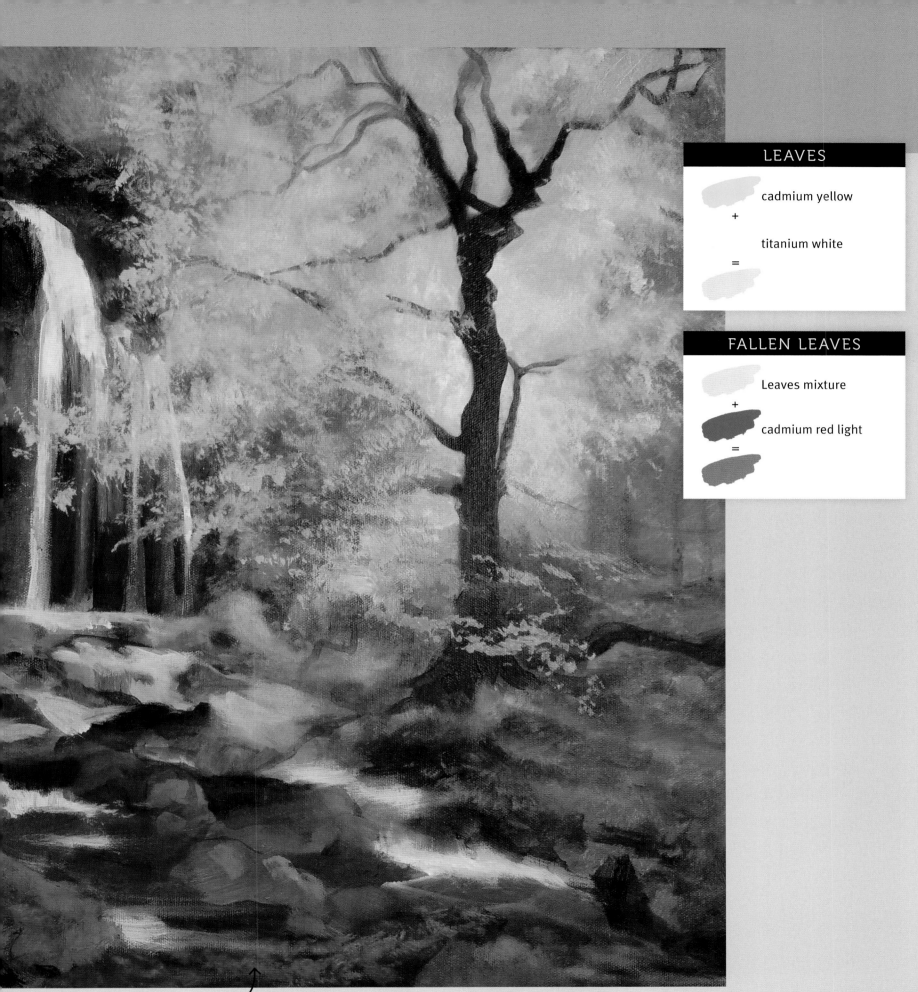

LEAVES

cadmium yellow

+

titanium white

=

FALLEN LEAVES

Leaves mixture

+

cadmium red light

=

Add cadmium red light to the leaves mixture to suggest fallen leaves on the ground.

With a large fan bristle brush, apply the leaves mixture and touches of brilliant yellow green using a tapping and stippling motion to create a realistic look of foliage.

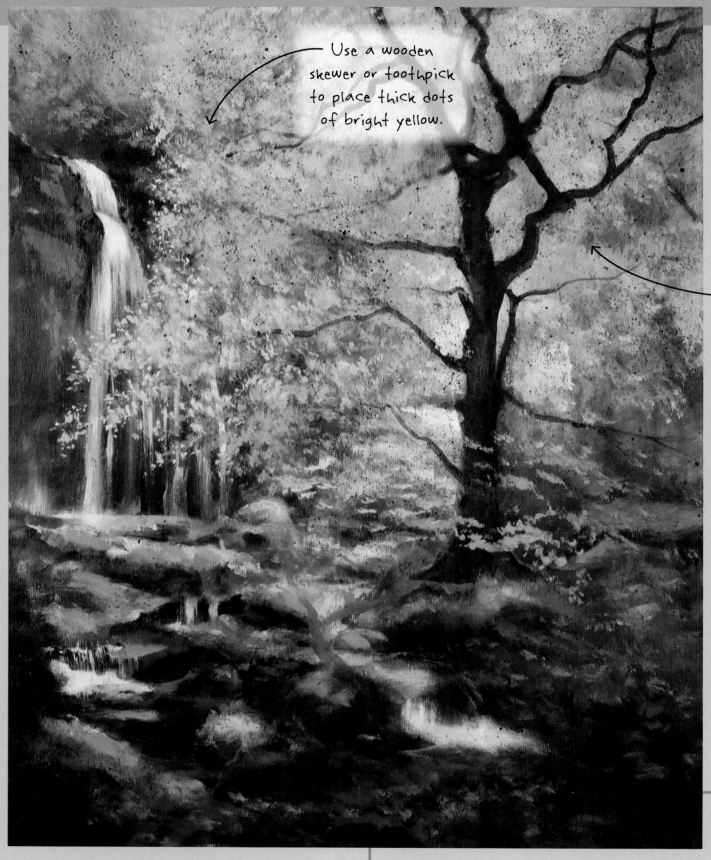

Use a wooden skewer or toothpick to place thick dots of bright yellow.

Use an old toothbrush to splatter watery brown paint.

Add another branch to the main tree form to balance the composition, and add additional texture to the foliage.

Detail Add a light scumble of ultramarine blue to the edge of the waterfall and lower area of water.

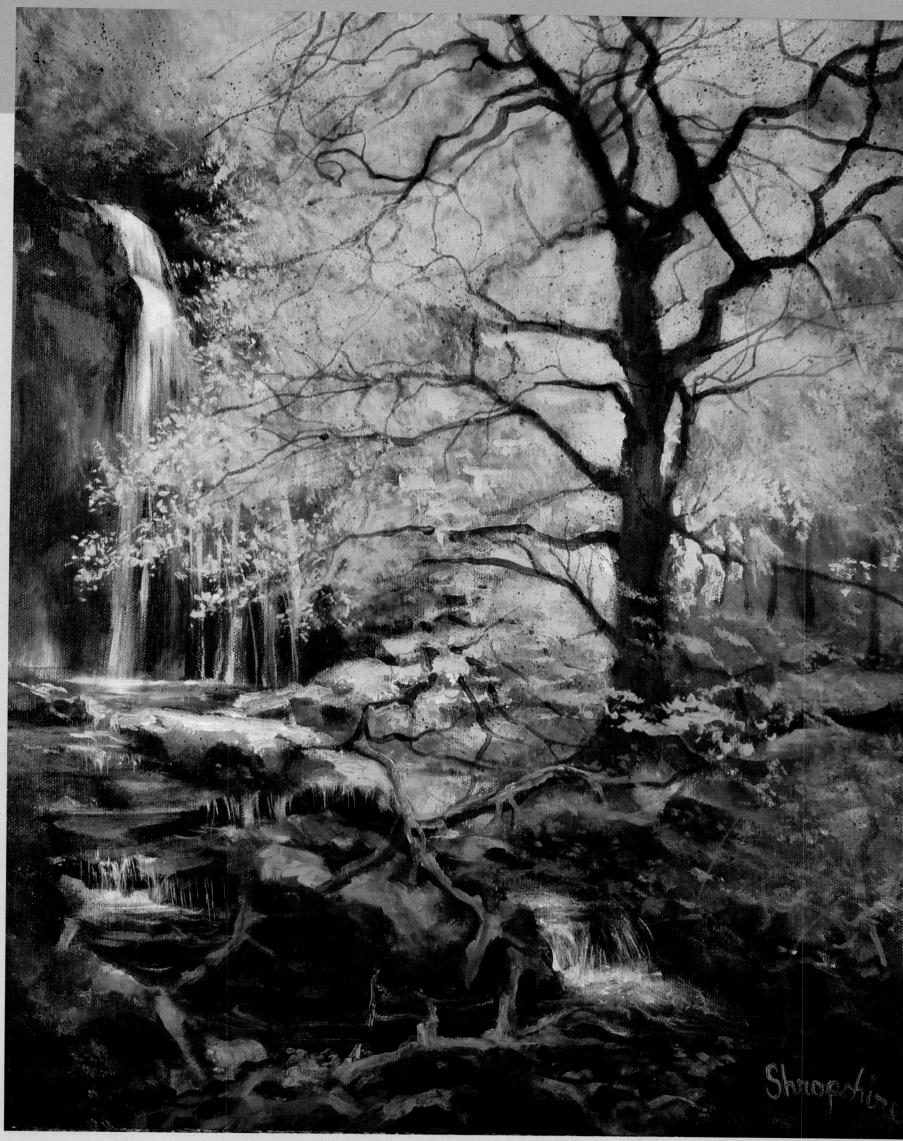

Define the rocky area and paint the smaller tree branches. Add any final details as needed. Alter colors—intensify or tone them down—and place accents to add sparkle.

ADDING DRAMA

Build off of your reference photo by taking artistic license. The reference photo in this project has a pale, bluish sky, but switching to a sunset sky will add drama and enhance your subject.

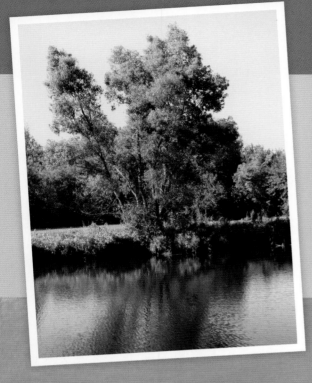

Dampen the canvas with a sponge, and use a large bristle fan brush to block in the background colors, establishing initial lights and darks. Treat the painting like a rough sketch, brushing quickly and using wet-into-wet blending for a soft, hazy look. Let the paint dry.

SKY BLOCKING

ultramarine blue

+

titanium white

+

touch of yellow oxide

=

BACKGROUND

brilliant green

red oxide

Brush brilliant green into the area below the tree line.

Add red oxide under the shoreline.

BACKGROUND TREES

Hooker's green

+

yellow oxide

=

Hooker's green

+

burnt umber

=

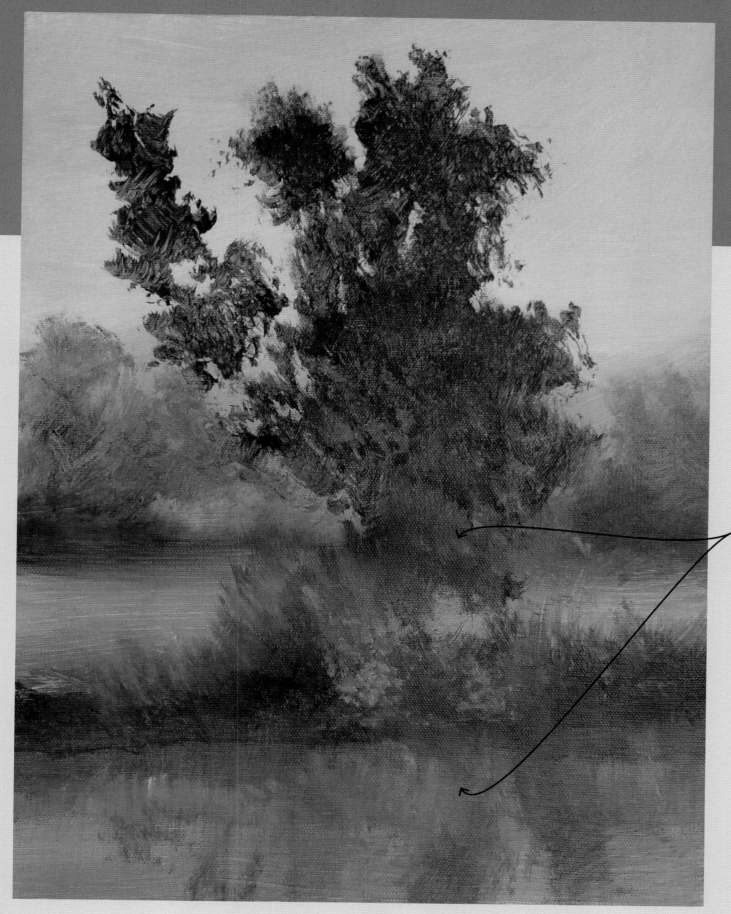

Add red oxide and yellow oxide to create color variation in the tree leaves and to establish the tree's reflection.

Using the large bristle fan brush, tap and scrub the darker background trees mixture to indicate the shape and mass of the tress in the foreground.

TIP

Tube greens are usually too strong and unnatural looking for landscape painting. It's best to mix your own.

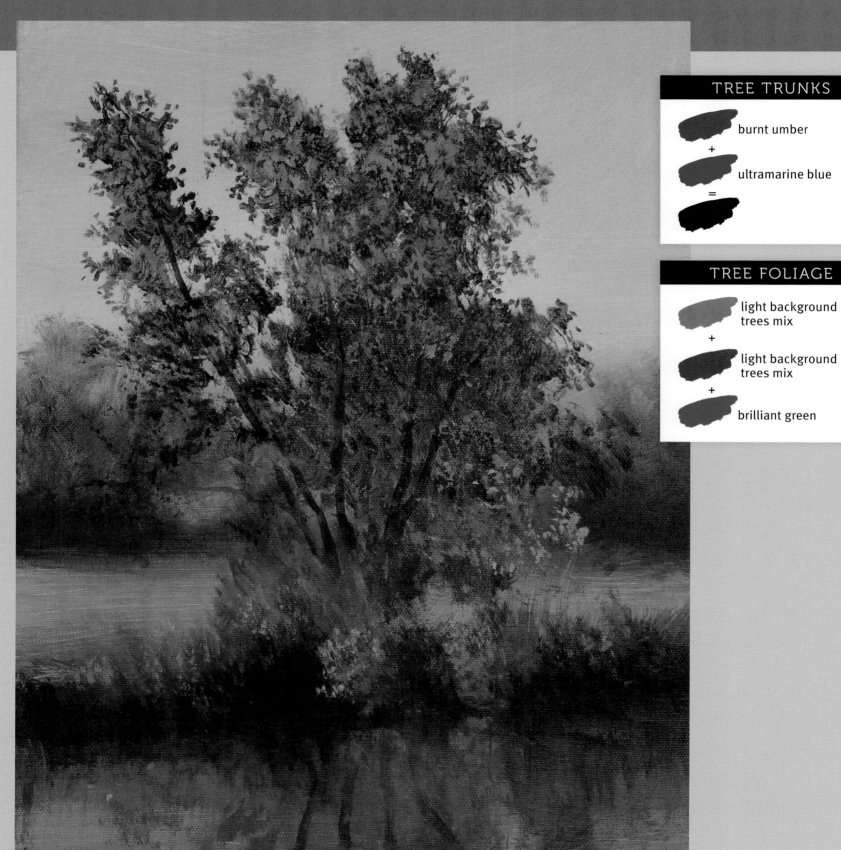

TREE TRUNKS

burnt umber

+

ultramarine blue

=

TREE FOLIAGE

light background trees mix

+

light background trees mix

+

brilliant green

Apply various shades of the tree foliage colors using a sponge and bristle fan brush to add dimension and texture to the foliage. Indicate the shapes of the tree trunks with a mixture of burnt umber and ultramarine blue. Let this layer dry completely.

TIP

If the tint doesn't turn out how you would like, simply remove it with a wet sponge and try again!

Dampen the canvas with a sponge. Over the entire surface, use a #6 fan brush to apply a transparent tint by glazing over with the sky tint mixture.

SKY TINT

quinacridone red

+

touch of cadmium yellow

=

Detail The reference photo has a pale, bluish sky, but switching to a sunset sky in yellow-and-orange hues will add drama and enhance your subject beyond simply copying the photo.

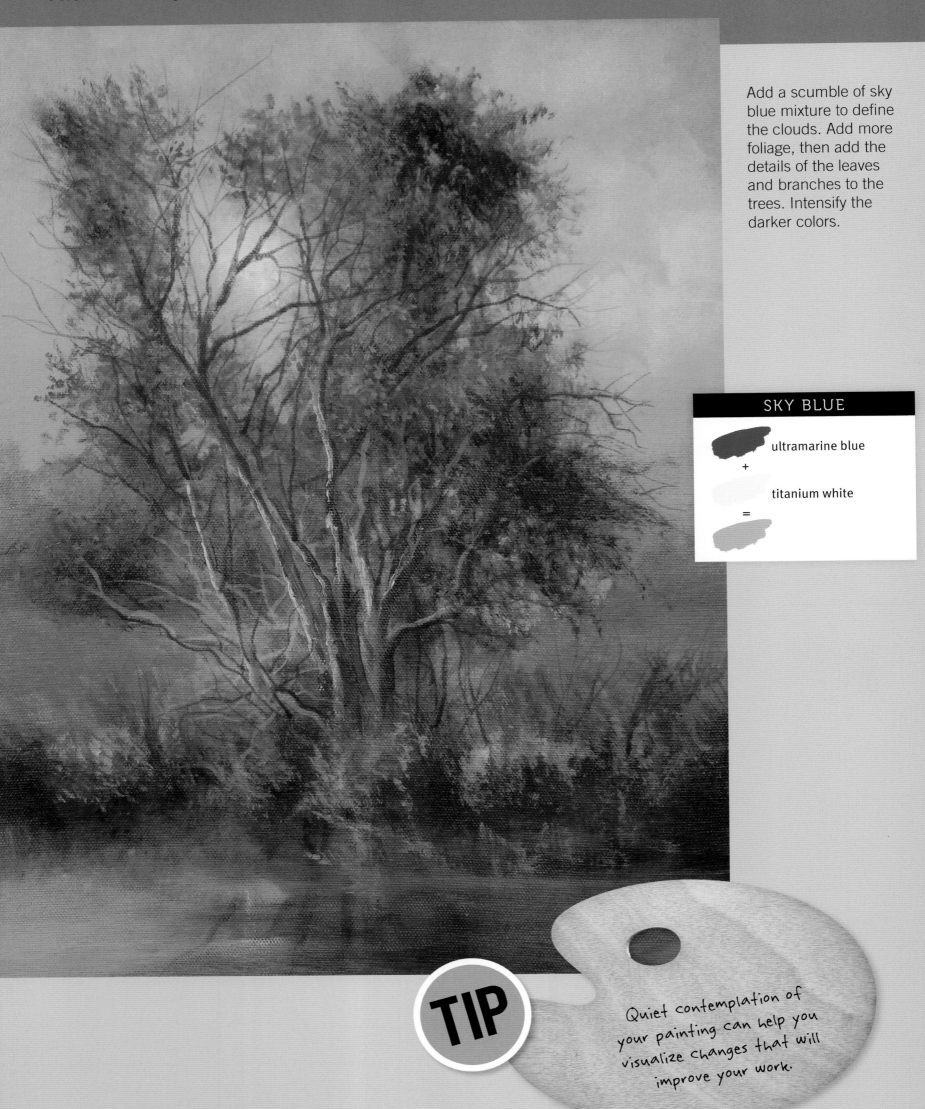

Add a scumble of sky blue mixture to define the clouds. Add more foliage, then add the details of the leaves and branches to the trees. Intensify the darker colors.

SKY BLUE

ultramarine blue

+

titanium white

=

TIP

Quiet contemplation of your painting can help you visualize changes that will improve your work.

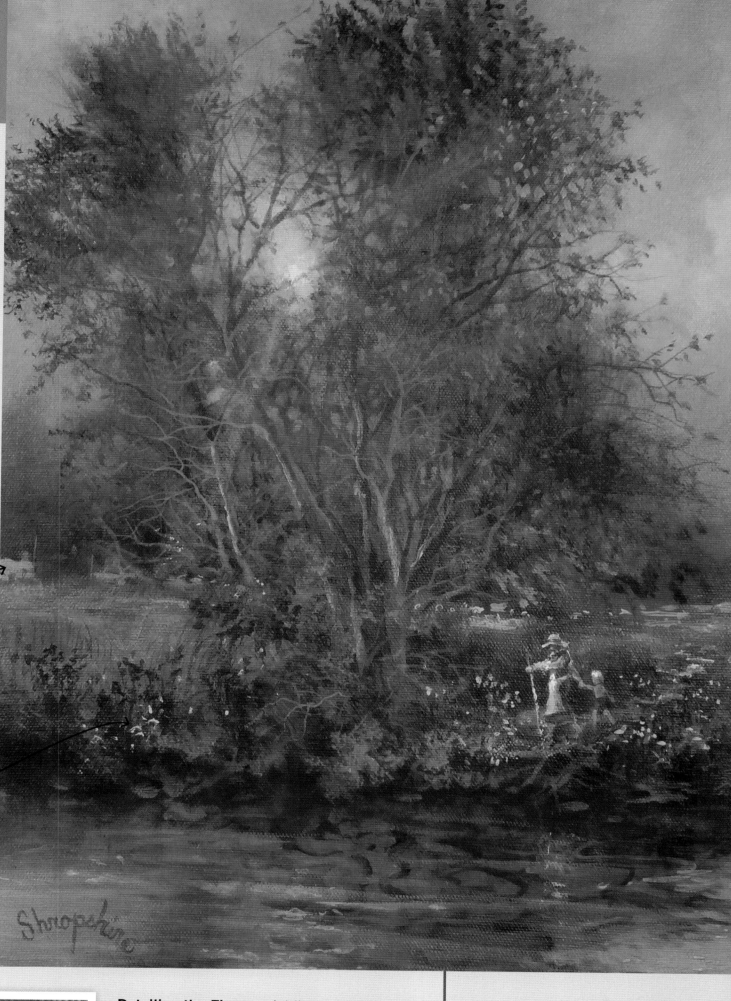

Darken the shoreline and suggest wavy reflections in the water. Add a thin layer of cadmium red light to create the halo effect of the sun shining through the trees. Add cadmium orange to imply reflected light.

Add shapes to imply farm structures in the distance.

Add a few bright spots of titanium white to imply flowers on the riverbank.

Detailing the Figures Adding a figure or two in the lower right section of the composition creates interest and establishes the trees' scale. Using the tip of a wooden skewer (or toothpick) and some thick pigment, indicate a couple of figures, such as a parent and a child. Details aren't necessary, as the pigment's brightness will draw the viewer's eyes to the area and guide them into the landscape.

HIGHLIGHTING SPECIFIC ELEMENTS

Highlighting a particular element of your painting can create interest and depth. In this painting, all of my color and composition choices are focused on emphasizing the trees in blossom.

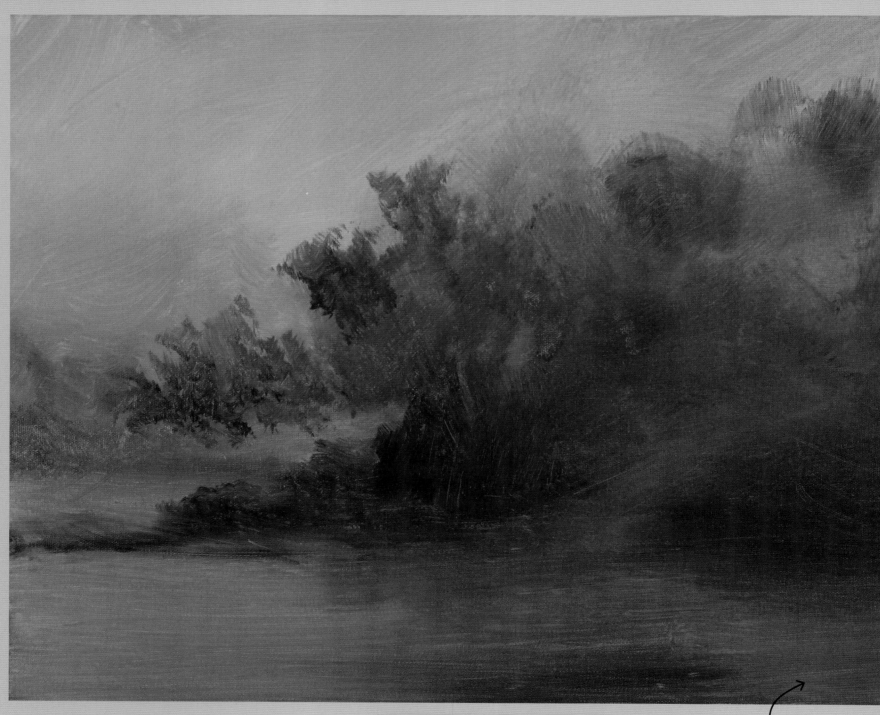

Use a #6 bristle fan brush to cover a dampened canvas with various mixtures of the background colors. Indicate the tree shapes with a mixture of Hooker's green and red oxide.

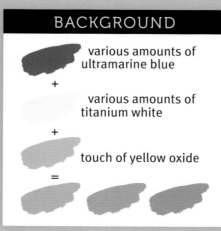

Suggest shoreline with a mixture of red oxide and a bit of yellow oxide.

BACKGROUND
various amounts of ultramarine blue
+
various amounts of titanium white
+
touch of yellow oxide
=

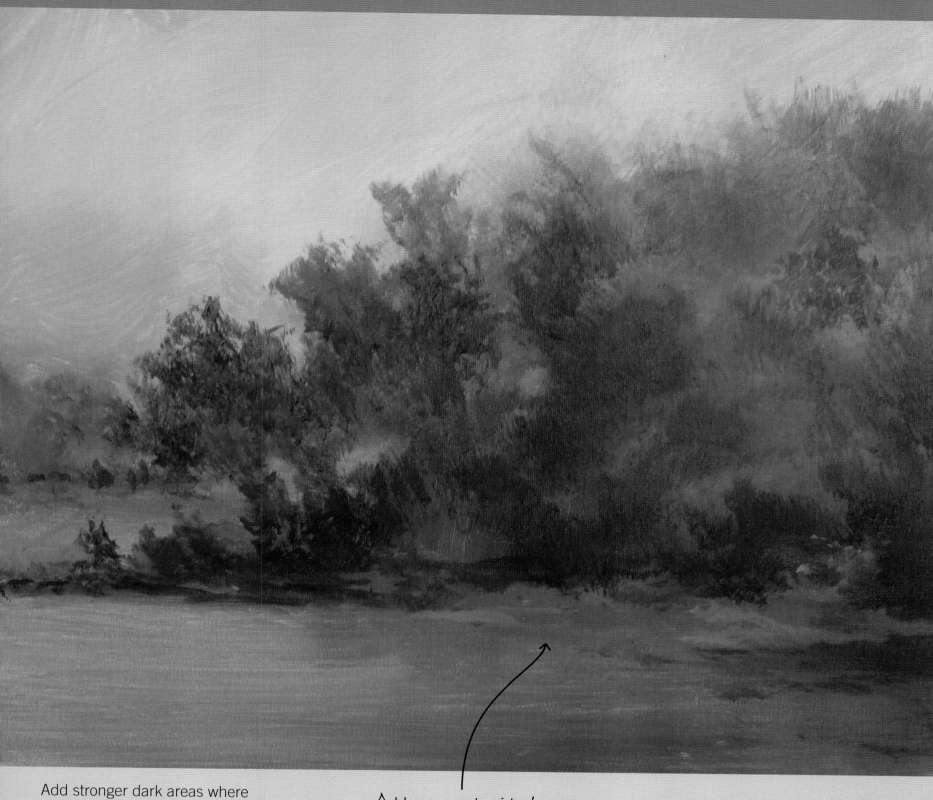

Add stronger dark areas where needed, and strengthen the contrasts between light and dark without adding too much detail.

Add more red oxide to define the shoreline.

TREE SHAPES

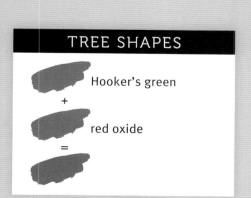

Hooker's green

+

red oxide

=

TIP

Creating defined lights and darks sets a strong base to develop details and textures later.

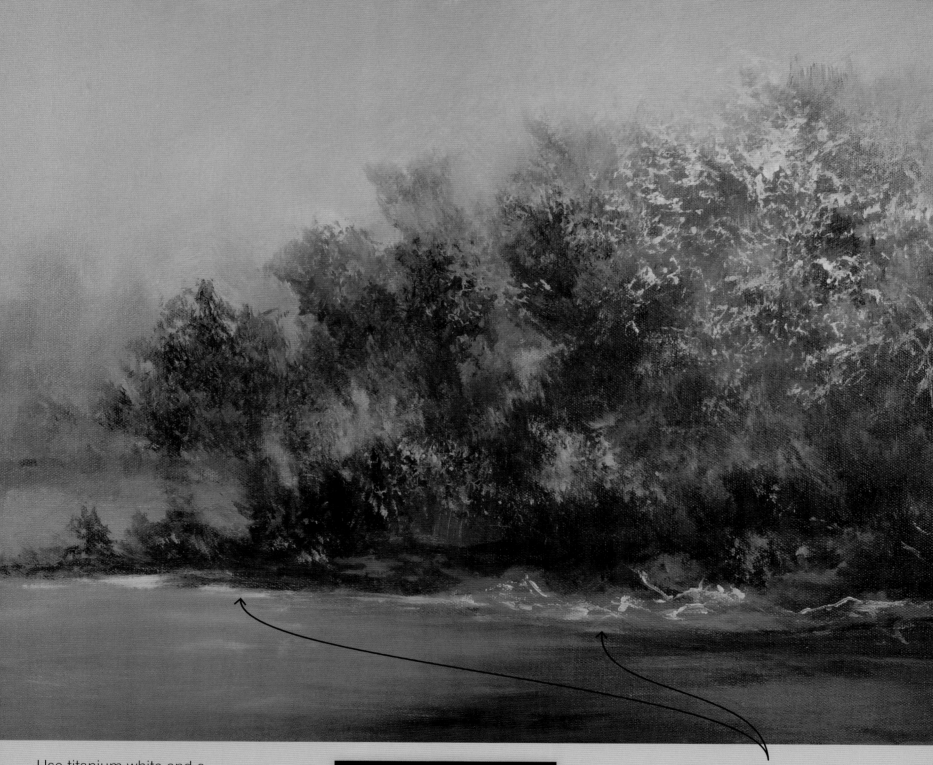

Use titanium white and a small piece of sponge to dab in the tree's new blossoms. Then use the light tree foliage mixture to apply more light areas to the middle section of the trees.

LIGHT TREE FOLIAGE

brilliant light green

+

titanium white

+

Add highlights using titanium white to areas where the light catches.

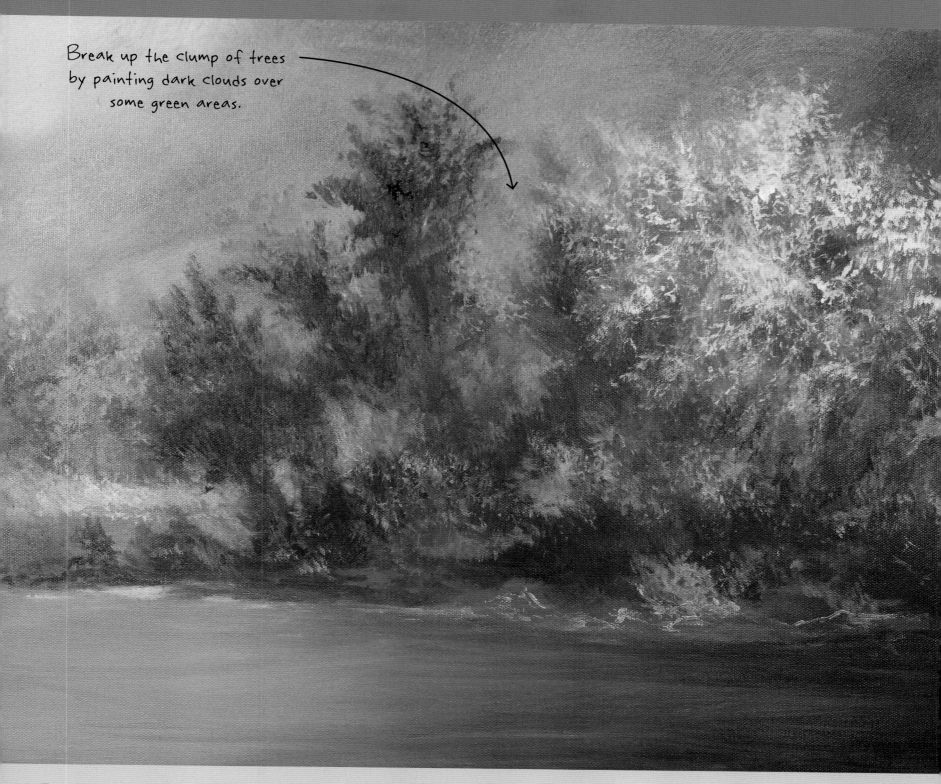

Break up the clump of trees by painting dark clouds over some green areas.

To emphasize the white tree blossoms, darken the color of the sky and add darker clouds to increase the contrast in your painting.

TIP

Lighting is one of the most important aspects of any painting, regardless of subject. Establishing the source of light and adding the light's sparkle will make your painting pop.

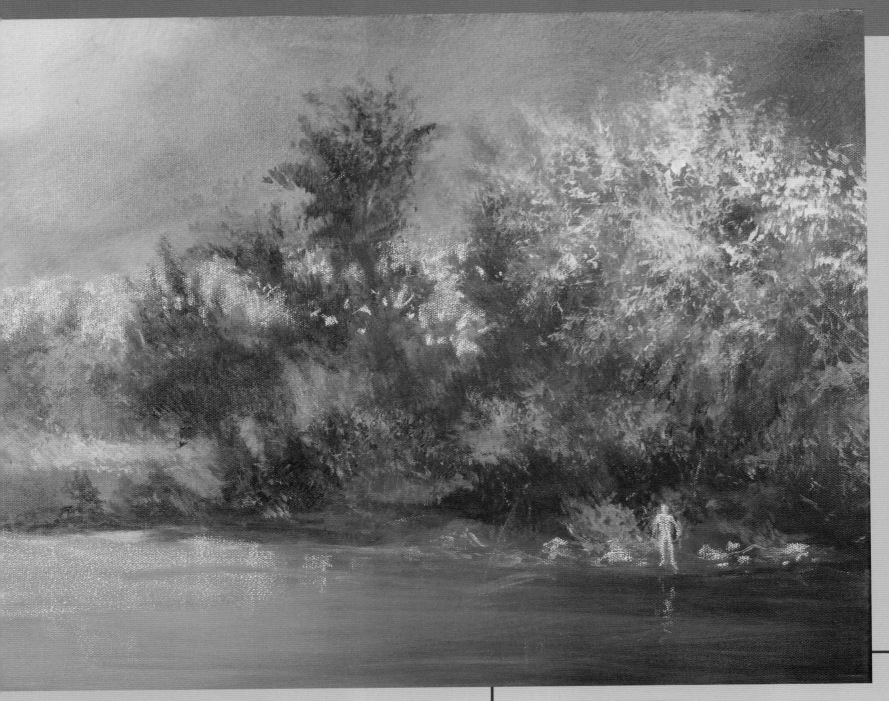

Using chalk, draw over the tops of the background trees to add a lighter streak in the sky, lowering the horizon line of the distant trees.

TIP

Using chalk is an easy way to test changes you want to make to your painting. If you like the changes, simply paint over the chalk. If not, use a damp sponge, brush, or tissue to erase.

Detail Adding a small figure to the painting, like a fisherman, can help the composition and establish the scale of the scene. Use a small piece of chalk to draw a figure of a fisherman. If you don't like the pose, wipe off the chalk and try a different one.

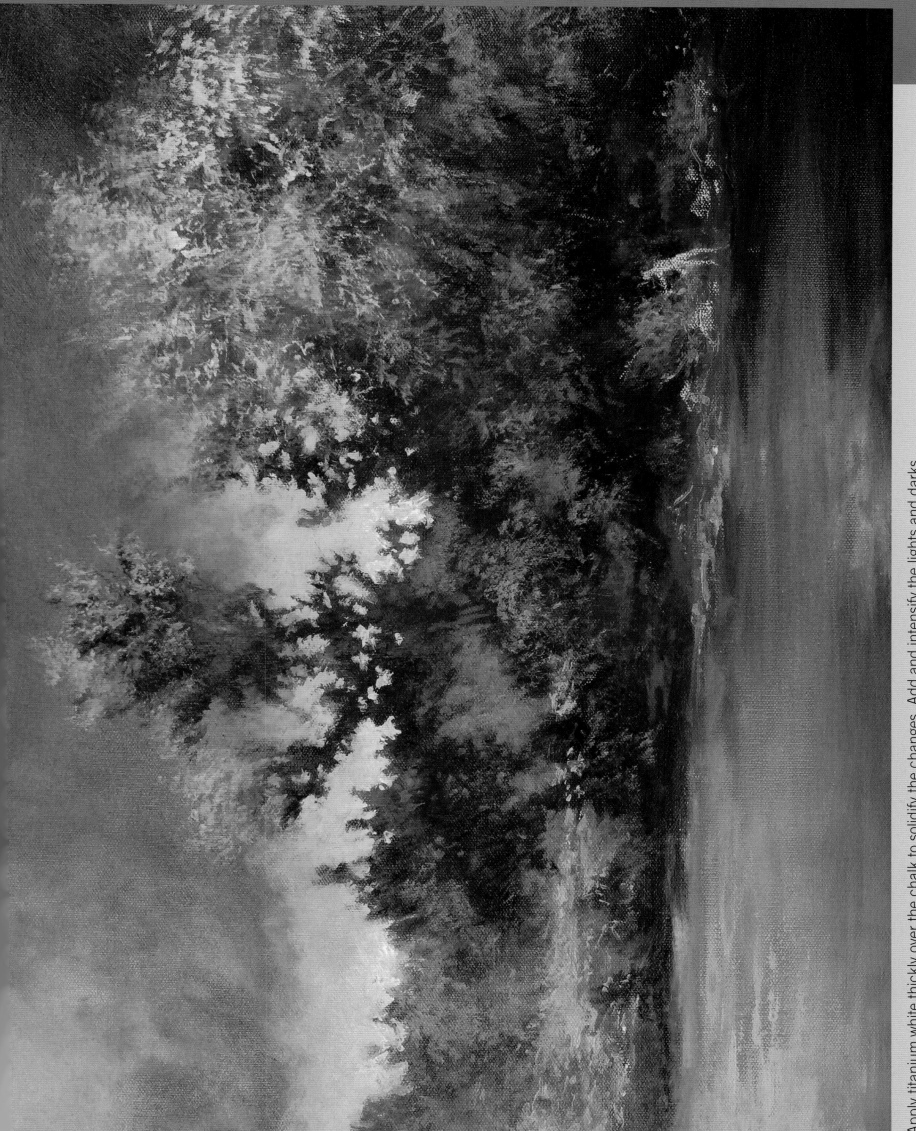

Apply titanium white thickly over the chalk to solidify the changes. Add and intensify the lights and darks.

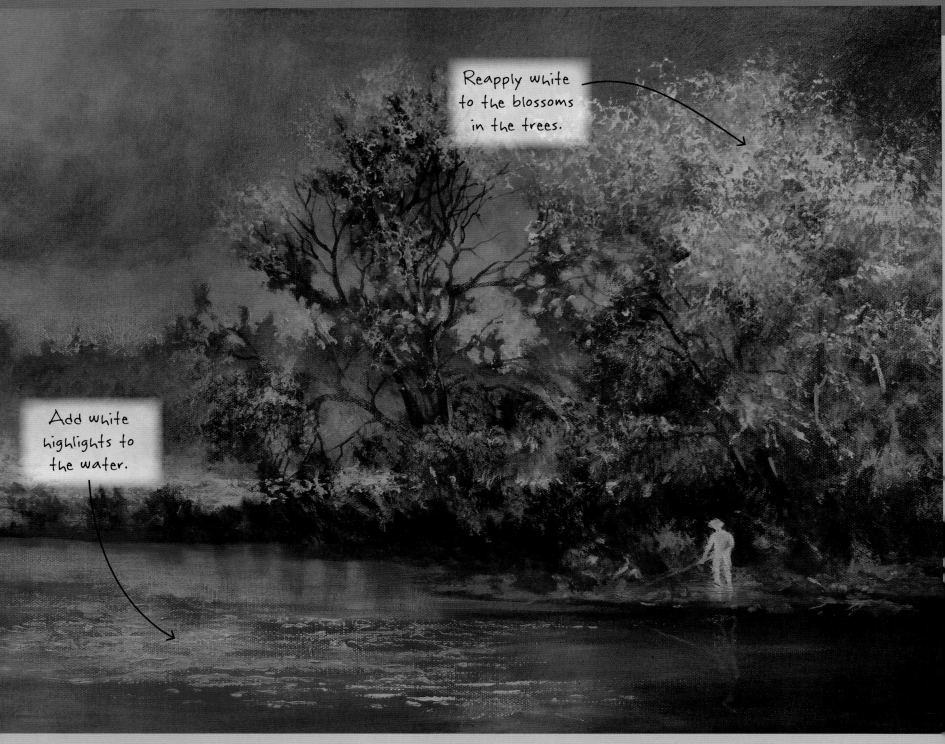

Reapply white to the blossoms in the trees.

Add white highlights to the water.

Add tree trunks and branches. Use a fan bristle brush to apply a wash of diluted bright aqua green to tint the sky just below the storm cloud and the water.

Detail The aqua green wash is perfect to depict the powerful and vivid colors of a stormy sky.

Don't be afraid to use artistic license and your imagination to determine what details are needed to express your vision.

TIP

WASH

bright aqua green

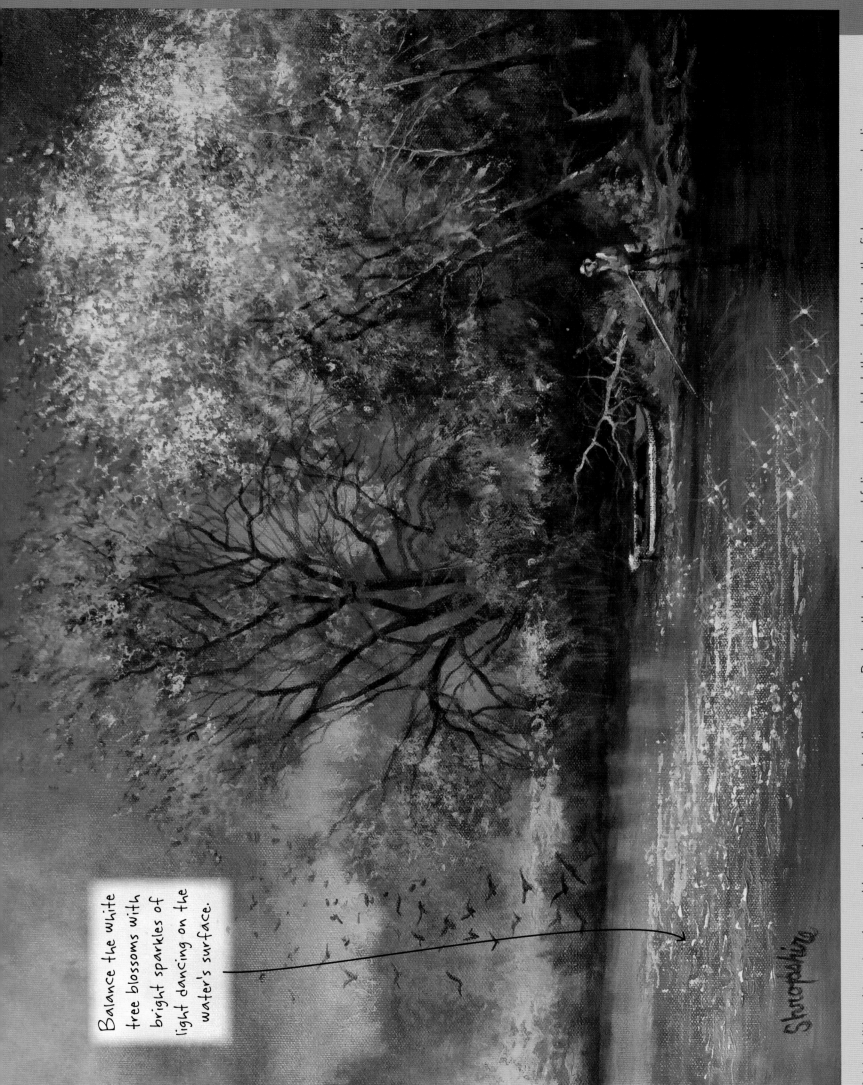

Balance the white tree blossoms with bright sparkles of light dancing on the water's surface.

Shropshire

Add additional tree trunks and branches to complete the trees. Darken the tree trunks and foliage, and add clothing details to the fisherman, including a touch of cadmium red medium for his shirt. Add a fishing boat pulled up on the shore, an overhanging branch near the boat, and a flock of birds to add interest to the scene.

DEPICTING LANDMARKS

Landmarks add appeal and interest to any landscape scene. Use basic shapes and small details to capture its essence. This landmark, Holy Hill Basilica, is located in southeastern Wisconsin, situated on a high kame.

Dampen the entire canvas with a wet sponge. With a #6 bristle fan brush, block in the background colors, establishing initial lights and darks. Keep strokes quick and loose, and work top to bottom.

BACKGROUND

cadmium orange

cadmium red light

dioxazine purple

titanium white

yellow oxide

TIP

Chalk guidelines can help determine where to place the middle ground and foreground.

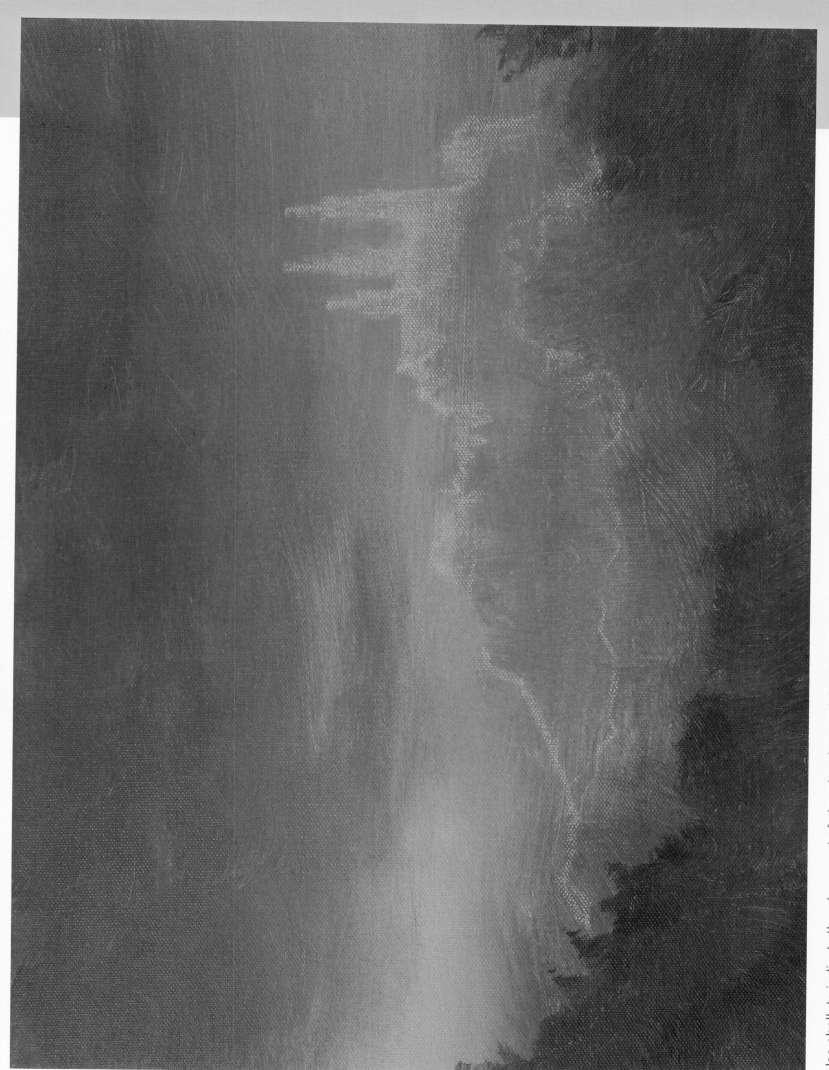

Use chalk to indicate the placement of church spires and the shape of the hills along the horizon.

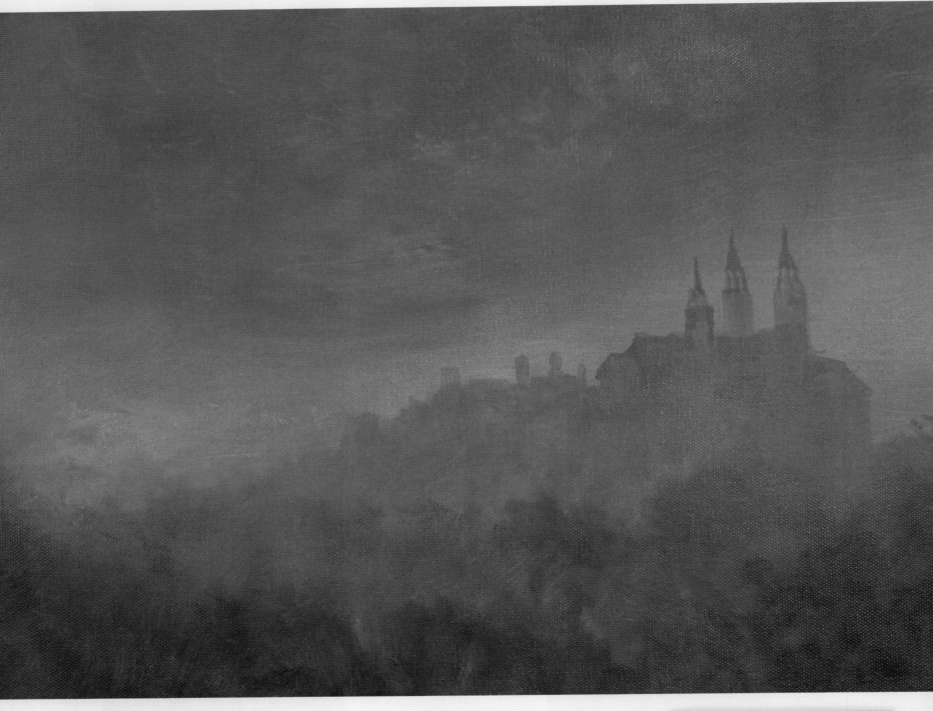

Use a #8 bristle bright brush loaded with the church mixture to scumble in the distant church shape (see page 6 for technique). Use a #4 bristle bright brush to suggest the shapes of the spires.

CHURCH

cadmium red light

+

dioxazine purple

+

titanium white

=

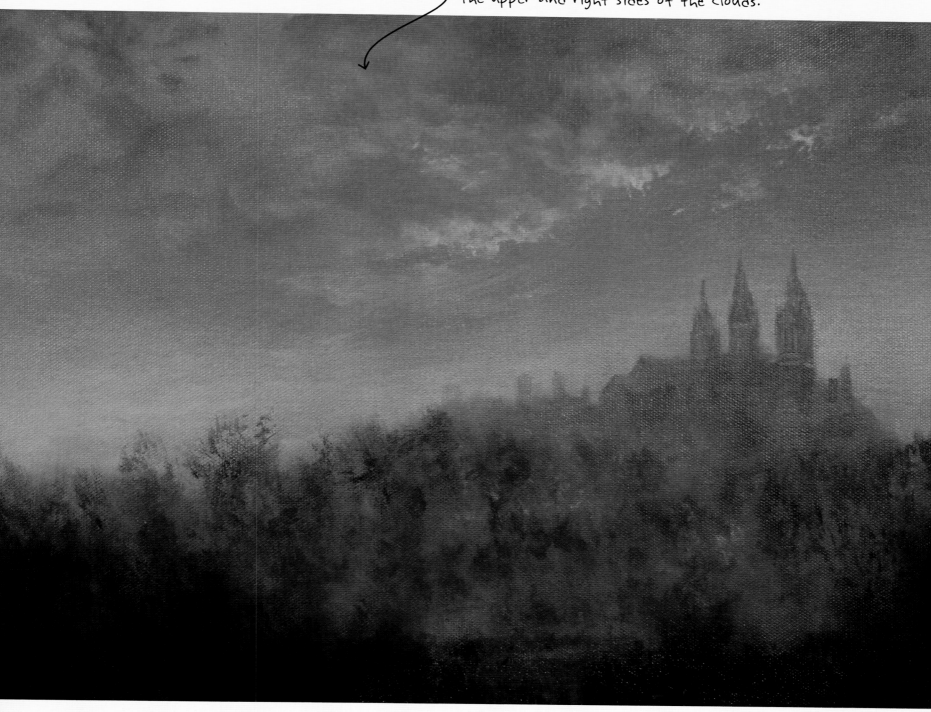

Use a bristle brush to soften the edges on the upper and right sides of the clouds.

Apply the clouds and foliage mixture thickly to form sunlit cloud shapes and to add brilliant fall foliage. Add the dark foliage mixture to anchor the foreground.

CLOUDS & FOLIAGE

cadmium orange

+

cadmium red light

=

DARK FOLIAGE

Hooker's green

+

burnt umber

=

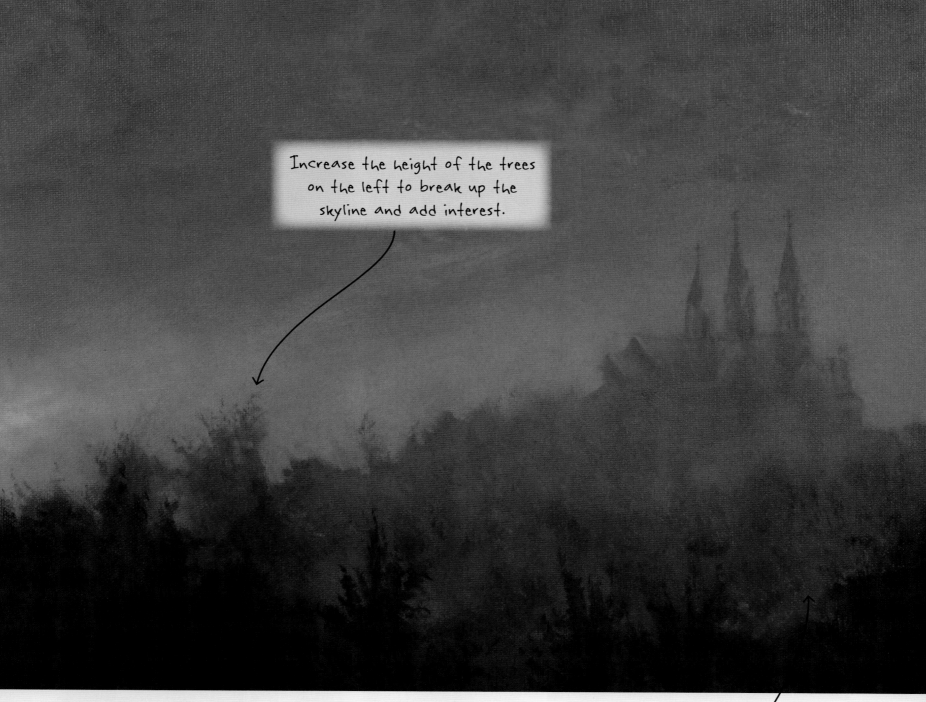

Increase the height of the trees on the left to break up the skyline and add interest.

Apply cadmium red light straight from the tube for a splash of autumn color.

Re-establish the contours of the hills. Use a mix of dioxazine purple and titanium white to improve the church silhouette. With a fan brush, tap in some dark foliage and pine trees in the foreground using the dark foliage mixture.

TIP

If one of the church spires looks misplaced, paint over it with a matching sky color. Then repaint it in a more appropriate spot.

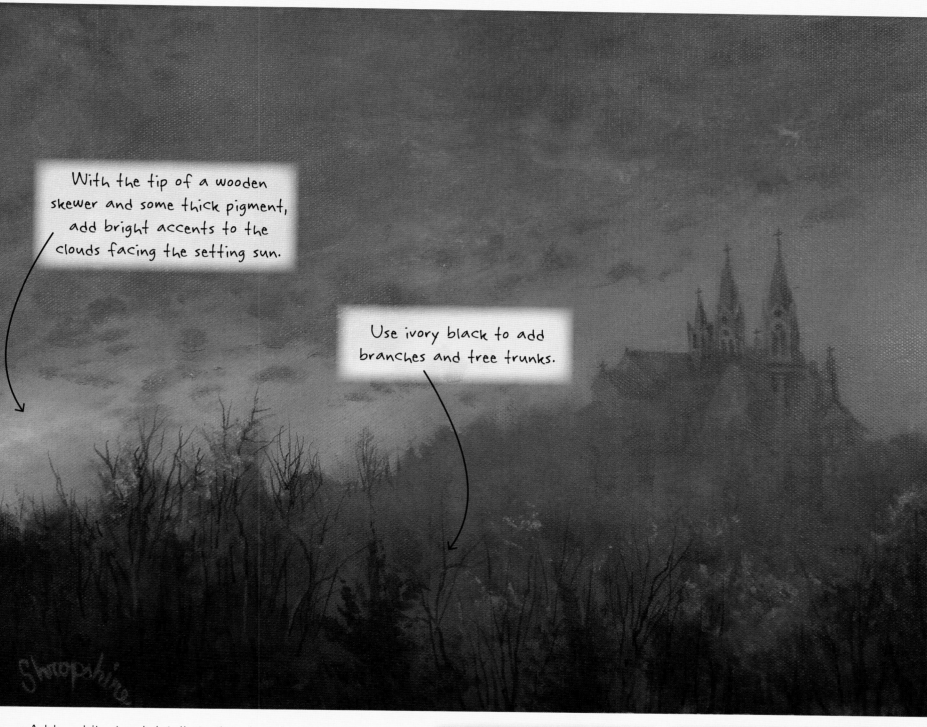

With the tip of a wooden skewer and some thick pigment, add bright accents to the clouds facing the setting sun.

Use ivory black to add branches and tree trunks.

Add architectural details to the church using the church details mixture. With a feathery light scumble, add cloud shapes to the left sky area using the dark clouds mixture. Use the clouds and foliage mixture to add texture to the foreground trees. Use the fan brush to apply a wash of diluted naphthol crimson to adjust the color of the clouds in the upper left sky area.

CHURCH DETAILS

Church mixture

+

touch of naples yellow

=

DARK CLOUDS

dioxazine purple

+

cadmium orange

+

touch of titanium white

=

WASH

naphthol crimson

PAINTING FROM MEMORY

Using visual memory will help to add unifying details to your painting. Develop your visual memory by sketching from life, studying photos, visiting art museums, and observing nature.

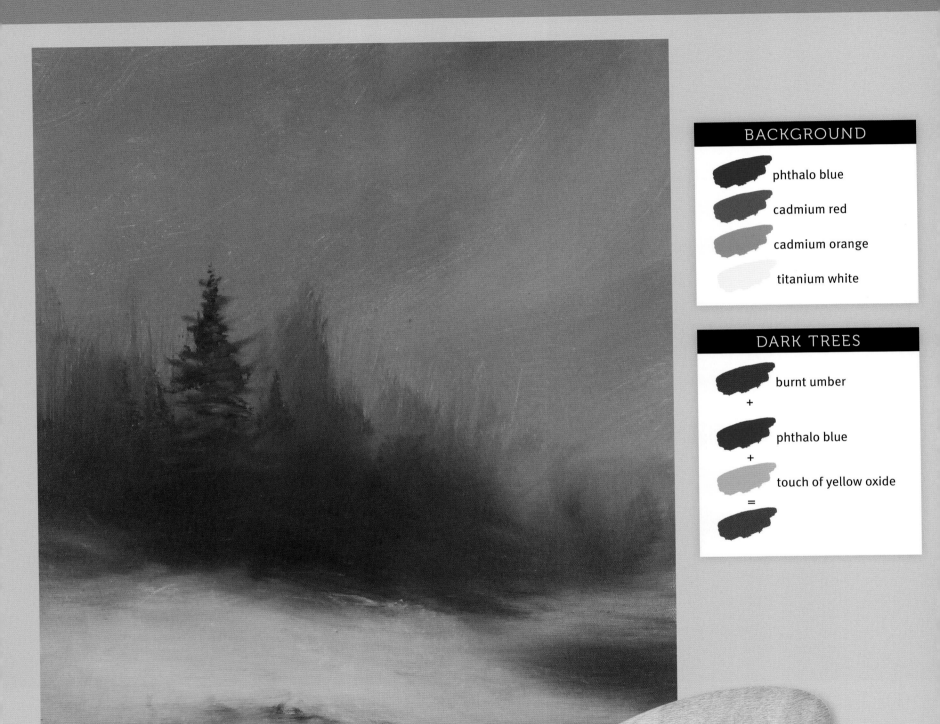

BACKGROUND

phthalo blue

cadmium red

cadmium orange

titanium white

DARK TREES

burnt umber

+

phthalo blue

+

touch of yellow oxide

=

Wet the canvas with a sponge, and use a #6 bristle fan brush to loosely apply various mixes of the background colors. Use the dark trees mixture to indicate the dark trees along the horizon and the frozen lake.

TIP

When starting a painting, don't be overly concerned with the details or the color palette. Concentrate on covering the primed canvas and creating a rough layout of the composition.

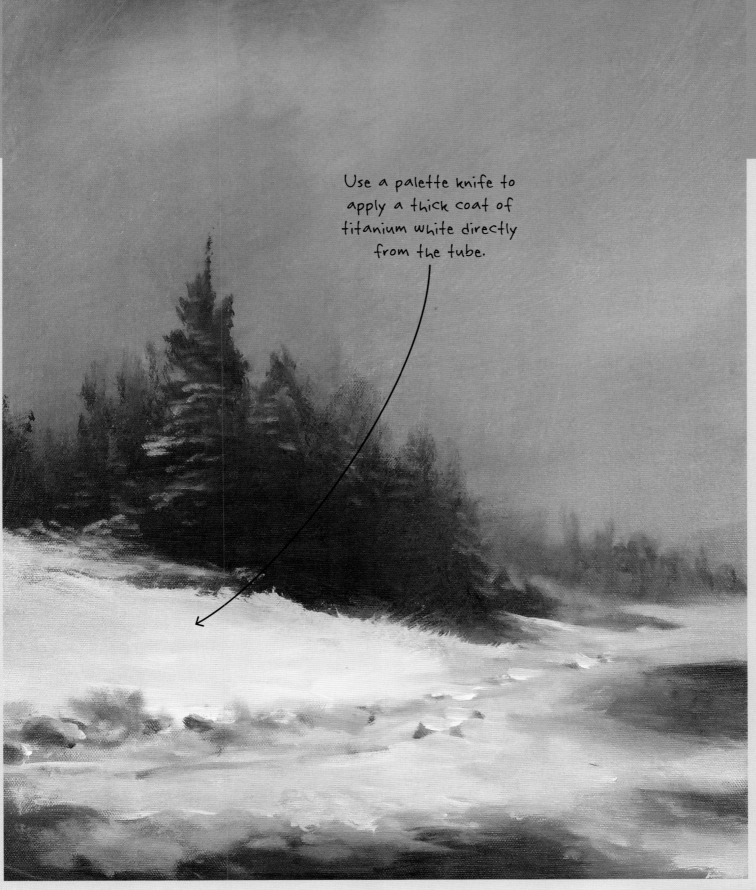

Use a palette knife to apply a thick coat of titanium white directly from the tube.

Adjust the color of the sky using various shades of the sky mixture. Softly indicate the clouds with a mixture of cadmium red light and white, and refine the trees using the dark trees mixture again.

SKY

ultramarine blue

+

various amounts of cadmium red light

+

various amounts of titanium white

=

Blackboard chalk is easy to erase and change with a damp sponge, brush, or tissue.

TIP

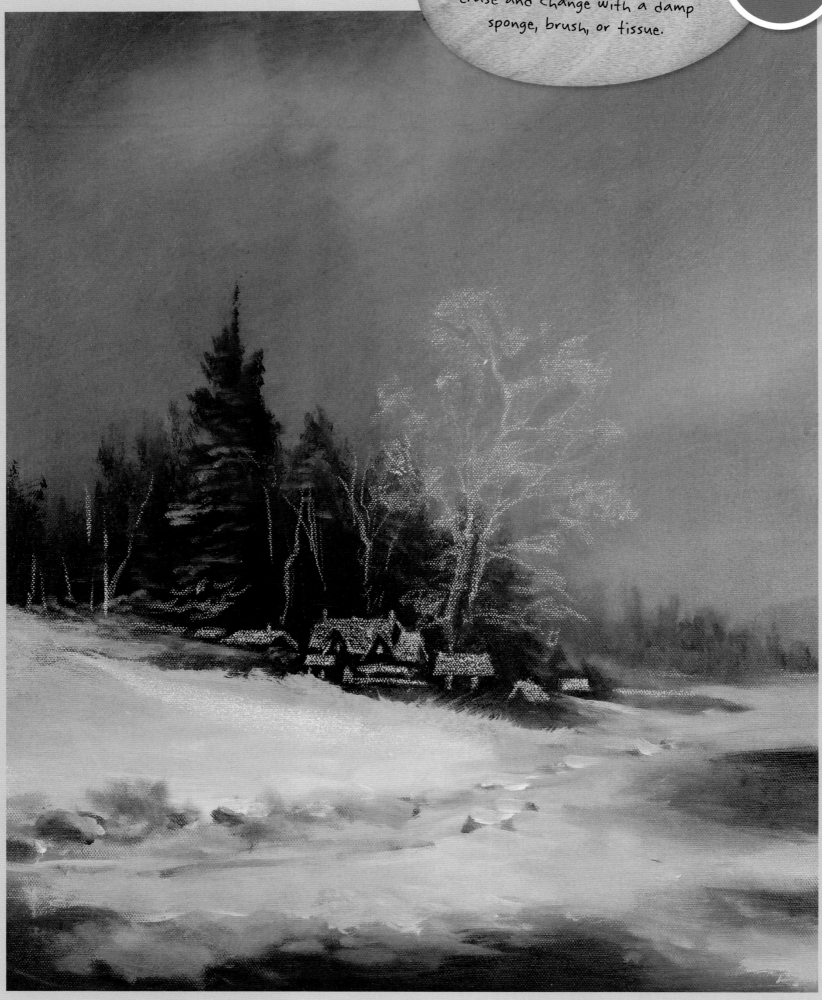

Use chalk to sketch roof structures, tree trunks, and a large tree to add interest and indicate scale.

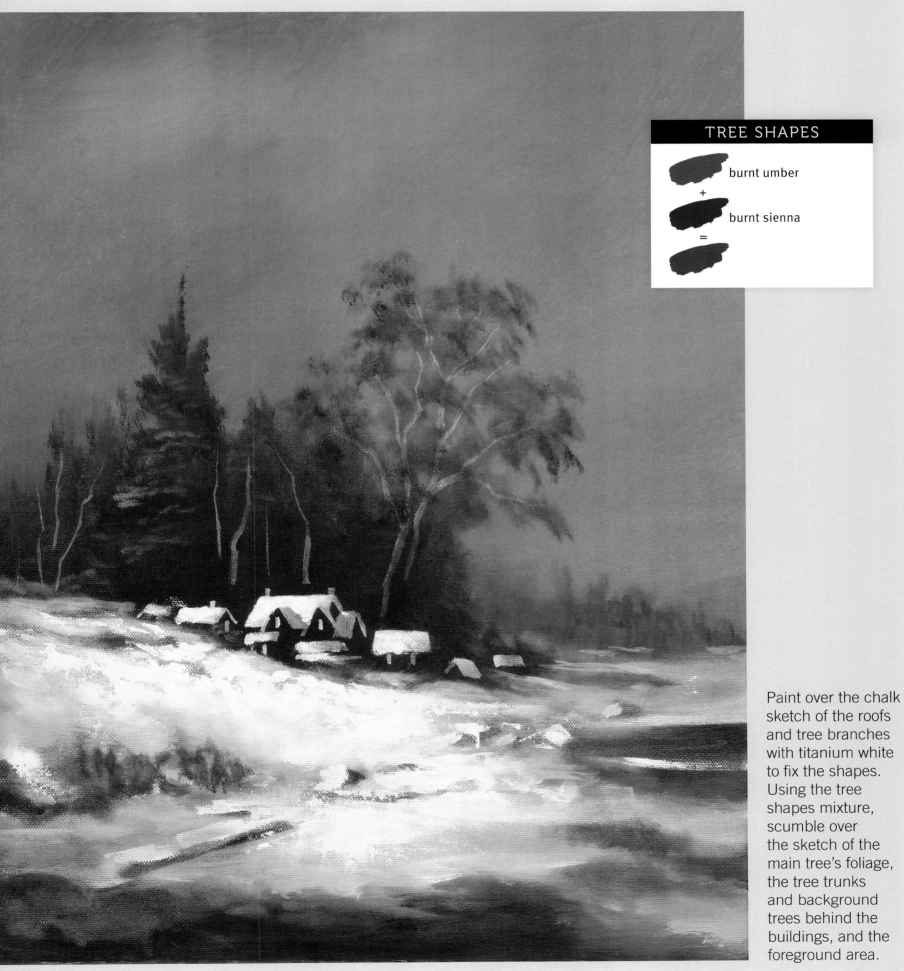

TREE SHAPES

burnt umber

+

burnt sienna

=

Paint over the chalk sketch of the roofs and tree branches with titanium white to fix the shapes. Using the tree shapes mixture, scumble over the sketch of the main tree's foliage, the tree trunks and background trees behind the buildings, and the foreground area.

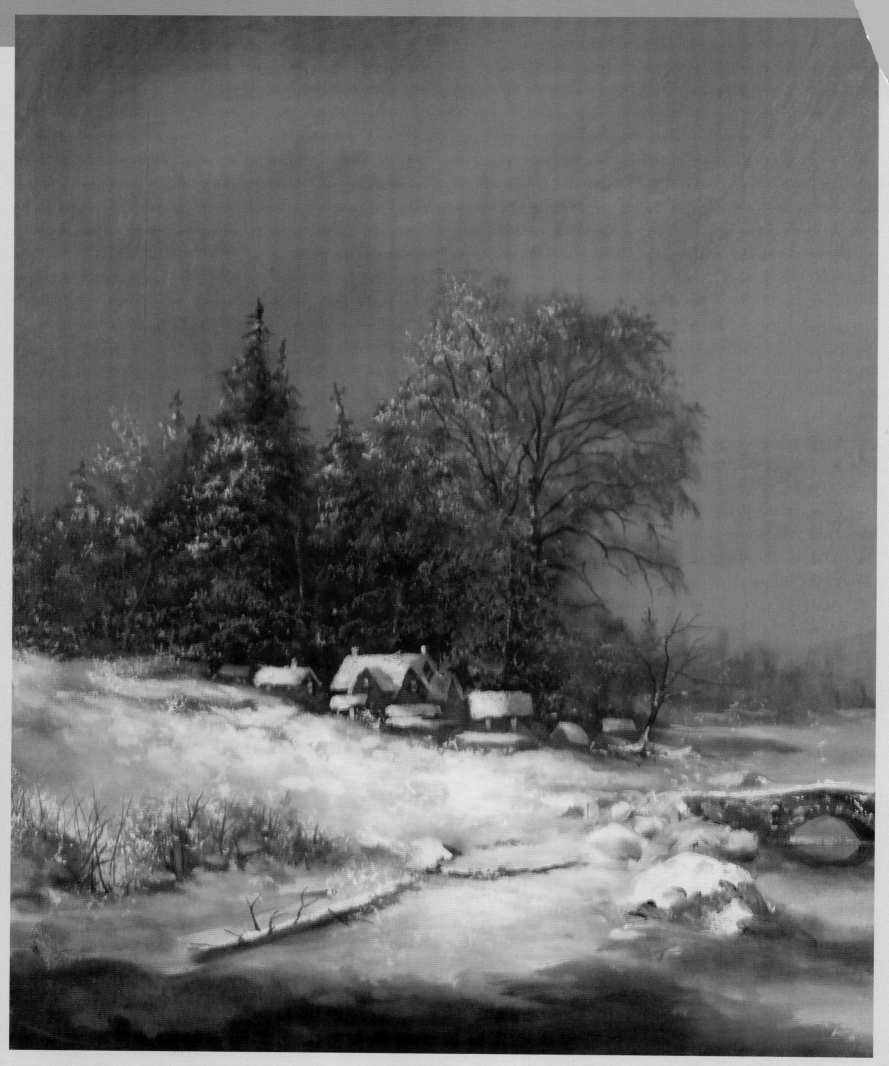

Add a stone bridge and a country lane leading toward the wooded area. Add lights in the windows. Add an orange glow to the treetops for a warm splash of color.

Use a damp sponge and titanium white to depict the snowy foliage on the trees and bushes.

Darken the sky to create more contrast and add dramatic highlights to the clouds. Brighten and add definition to the cloud shapes.

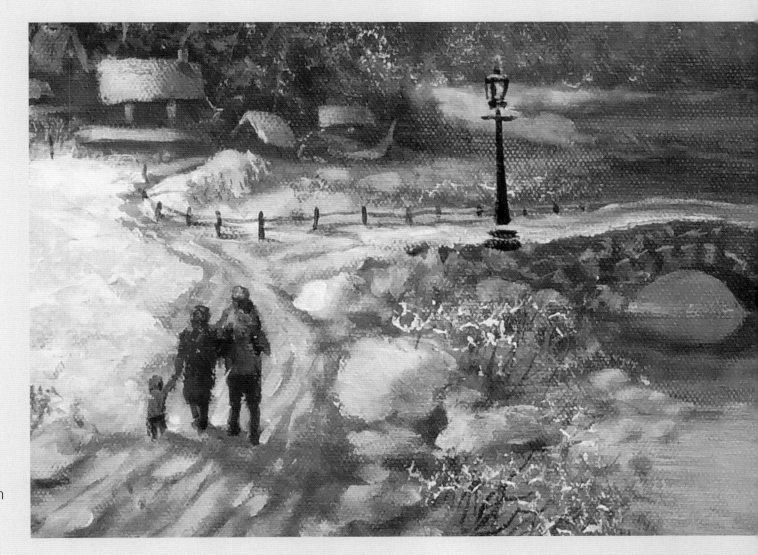

Add a road along the frozen lake, boulders, snow-covered branches, and a lamppost. Add the figures of a family out for a winter stroll. Sketch the figures with vine charcoal before painting them in.

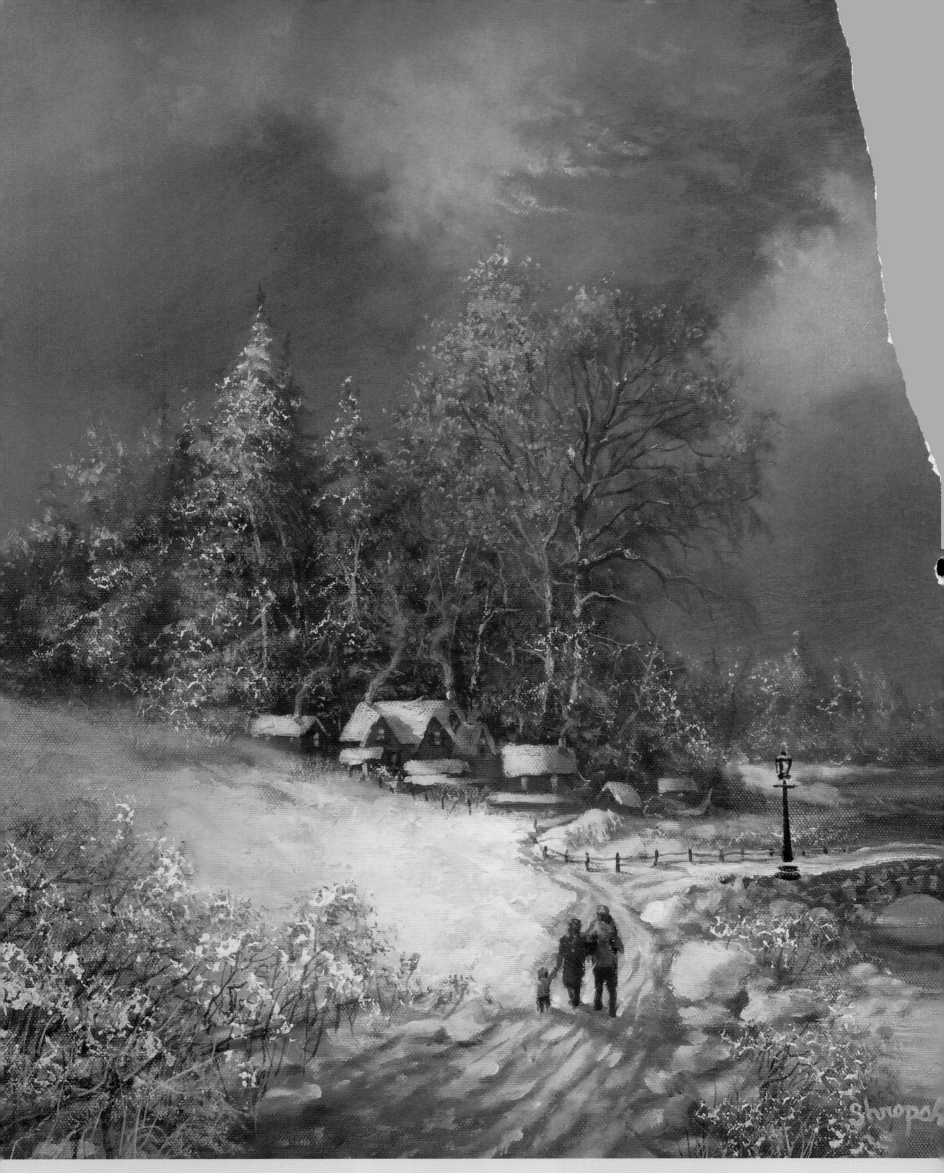

Intensify the darks and brighten the whites. Add a wash of cadmium red light over the cloud shapes. Add a wash of yellow oxide and cadmium red light over the white snow area. Add a tint of ultramarine blue to indicate shadowed areas.